THE
FANTASTIC
CREATURES
OF
EDWARD
JULIUS
DETMOLD

THE FANTASTIC CREATURES OF EDWARD JULIUS DETMOLD

Edited by David Larkin

Introduction by Keith Nicholson

Pan Books Ltd.
London and Sydney

This edition published 1976 by Pan Books Limited
18-21 Cavaye Place, London SW10 9PG

ISBN 0 330 24697 6

Published simultaneously in the United States and Canada

PRINTED IN ITALY BY MONDADORI, VERONA

'Seeing with a clear eye; without preconception, or association; beholding in all things, that only which they are.'
E. J. Detmold

Edward Julius Detmold, English engraver, water-colorist and illustrator, was born in Putney, London, in November 1883, the younger of twin boys. Together with his brother, Charles Maurice, who shared in every stage of his artistic development, he was an extremely delicate and precocious child. When they began to draw at the age of five, showing greatest interest in horses and monkeys, their father, an electrical engineer, decided the boys should be privately tutored. They went to live in Hampstead with an uncle, Dr E. Barton Shuldham, who personally supervised their early education, and whose knowledge of natural history encouraged their inherent inclination and aptitude. The boys began to study and draw animals at the Zoological Gardens in Regent's Park and the Natural History Museum in South Kensington. In the 1890s London Zoo was a charming walk from West Hampstead, via Swiss Cottage and Primrose Hill, where the boys would have obtained a fine view of the city spread out beneath them.

The Detmolds began to copy drawings by other artists with fair accuracy, and evinced a sympathetic feeling for color even at this early period. A childish delight in competitions led them to enter a monster color contest promoted by a well-known publisher and they succeeded in winning first prize. At eleven years of age they were drawing crayfish and shells, monkey skulls and butterflies. A year later each submitted two drawings to another fine-art competition, this time competing directly with adults, and Maurice Detmold gained third prize in both sections, winning five pounds and a gold medal. In 1897 both boys were exhibitors at the Royal Institute of Painters in Water Colours, and each had a drawing hung at the Royal Academy – at the age of thirteen, they were among the youngest ever to exhibit there. At this time their work was admired by, among others, Edward Burne-Jones, who strongly advised against the strictures of art school. Both brothers began experiments with etching, and with savings from their earliest sales

they acquired a printing press which they installed at Hampstead and used to execute their own proofs. In 1898 the two again exhibited at the Royal Institute and had made sufficient progress with their etching to issue jointly a portfolio of eight etchings of birds and animals. In the final year of the century Maurice again exhibited at the Academy, a still life, and Edward's work was hung in the Institute Gallery. Both boys were represented at the New English Art Club as well as at the International Exhibition in Knights-bridge, and also sent work, by special invitation, to Munich.

Early Publications

Another admirer of their output was the enterprising publisher J. M. Dent, who had earlier appreciated the talents of the struggling Aubrey Beardsley and given him his first book commission. Dent was so struck with the merit of the Detmolds' work that he commissioned them also to complete a book of colored illustrations. This book, *Pictures from Birdland*, published in 1899, is remarkable in many ways. Particularly noticeable are the early influences in the paintings, Edward's design for an osprey, with its unusual water effects, testifying to a Japanese contribution. Already apparent is that style in which a searching study of natural forms, especially bird plumage, is subordinated to decorative arrangement. Also that year appeared the first of a series of etchings executed jointly by the two brothers, each working on the same plate, a scheme which continued at intervals until 1904. In all Maurice produced ten etchings and two woodcuts in collaboration with Edward, and twenty-five etchings executed entirely by himself, though in part from drawings by his brother. Edward's work at this time does not have his brother's assurance and maturity, but the technical ability displayed in the best of them, especially the last of the joint works, is remarkable. In May 1900 the Detmolds held an exhibition of their prints and water-colors at the Fine Art Society's Galleries.

As the new century advanced, their reputation and success considerable and assured, the brothers commenced work on what was to be their finest joint achievement, a set of sixteen illustrations of subjects from Kipling's *Jungle Book*. This was first issued by Macmillan in 1903 as a large portfolio of colored plates, looseleaf, without text. A wonderful production, in green linen with silk ties, the upper cover was gilt-stamped with a striking pictorial representation of a winged beast (a mythic emblem employed by the Detmolds). The water-colors themselves must be among the finest book illustrations ever produced. Edward's contributions are bolder in outline, while those by his brother appear to have greater depth and more sense of artistic impression. There is an allegorical suggestion of Adam's naked innocence in illustrations by both artists, and the link with man in Paradise is emphasized in the undoubted masterpiece of the collection – *Kaa the Python* (Plate 5) – where Maurice Detmold's imagination, like Milton's, seems to have found greater

inspiration in a mischievous subject. Macmillan issued the illustrations again in 1908 with the full text, this time reduced to a disappointing octavo format in their standard Kipling edition. (Edward Detmold later contributed seven full-page illustrations for the *Second Jungle Book* to successive issues of the *Illustrated London News*, from October 1910 to January 1911, but these were never issued in book form.)

In 1904 the Detmolds contributed a joint etching to *The Artist Engraver*, and Maurice again exhibited at the Royal Academy Exhibition (*Beech Trees – Wiston*). In January 1905 they were elected Associates of the Royal Society of Painter Etchers, and contributed some of their best work to the 1905 Exhibition; but afterwards they resigned their membership. Two plates produced late that year were Maurice Detmold's last etched works.

Tragedy

For several years the two brothers continued to live with their uncle at Hampstead and spent part

of the year in Ditching, Sussex. On April 9th, 1908, when about to leave for the country, Maurice committed suicide by inhaling chloroform. He was twenty-four years old. The circumstances of his death are mysterious and inexplicable. At an inquest a verdict of suicide 'whilst unsound of mind' was recorded. In the coroner's words, a note left by Maurice 'expressed a desire on the part.of the deceased to end his life.' Dr Shuldham told the inquiry that since they were going to the country that day he had given the chloroform to Maurice, at his request, to put down the household cats, as he did not want them to stray. He had disposed of cats before in a similar manner. Edward explained how he had found his brother that evening in their locked bedroom, fully dressed, with a bag over his head, tied around the neck. A pad of chloroformed wool was placed to the mouth and three bottles were near. He also found two dead cats in a box. He told the coroner that his brother was most cheerful as a rule and was exceptionally successful in his work.

One can only conjecture upon the reason for such a desperate act in one so young and gifted. Was the artist so sensitive in his concern for natural creatures, as one might suppose, that the taking of other innocent lives upset the balance of his own mind? Or were there personal factors and motives unknown to those who knew him so intimately? Whatever the reason, one cannot help reflecting on the number of poets and artists who have died at an early age, as though a premature death was a condition of their calling. As with Chatterton, 'the marvelous boy,' it seems that visionary genius in youth dies in youth. But an artist's true life will always be the work which survives him and immortalizes his name.

The Lone Quest

Edward Detmold was profoundly disturbed by his brother's death, but it was some years before the loss would bear heavily upon him. The twins had collaborated in all their most important works,

but now an inseparable partnership had been rent asunder. Alone, Edward was still determined to achieve in the direction which the brothers had taken together. Experience now gave his work a *raison d'être*, a visionary gleam, which distinguish it from all other color illustrations of that time. A period of feverish activity followed: etching, wood and copper engraving, wood printing, fresco and glass painting; work in pen, pencil and brush; drawings of still life, in black and white and water-color, and wood-blocks in color after the Japanese manner. Armed with the humility Ruskin always espoused, Detmold produced in quick succession that magnificent series of book illustrations on which his reputation largely rests.

Confined for the most part to a realm of insects, plants, animals and birds, the concentration upon detail in the work goes a step further than Pre-Raphaelitism. Clearly influenced by early German art, especially by Albrecht Dürer, the paintings emphasize the decorative motive which underlies and is expressed in the natural detail. The arrangement of pattern in a bird's wing, the decorative armor of a fish's scales are treated minutely, but there is no sacrifice of movement. Detmold was seeking a synthesis of decorative effect (artistic impression) and the realistic emphasis of his subject matter (natural authenticity). He achieved this in some extraordinary ways, with the subject and the setting often in incongruous juxtaposition, creating a surreal or dreamlike effect. In other paintings he gave a dignity and sense of crucial integrity to a natural order increasingly menaced by human interference. Thus in his exquisite study of the wren for W. H. Hudson's *Birds in Town and Village* (1919), the bird occupies a visual center entirely encompassed by decorative flora; the subject and the setting are in natural harmony, the bird and its habitat are inseparably one. In *Fabre's Book of Insects* (1921) Detmold offers a remarkable study in diminutive activity and demonstrates, through an artist's microscope, that though much may appear

bizarre in the lower echelons of existence, there is nothing extraneous in the balance of nature. It is unfortunate that this collection did not include the remarkable painting of *The Ant Lion* (Plate 22), which Detmold contributed to *Princess Mary's Gift Book* in 1914.

Outstanding among the book illustrations are those commissioned by Hodder and Stoughton, who also published the work of Arthur Rackham, Edmund Dulac and Kay Nielsen, among others, mainly for the gift book trade. Detmold's finest plates are those produced for *The Fables of Aesop* (1909), *The Life of the Bee* (1911) and *Hours of Gladness* (1912), the latter with texts after Maurice Maeterlinck, the Belgian poet, naturalist and mystic. *Aesop's Fables* was issued with a striking cover, once more gilt-stamped with a representation of a phoenix-like, over-reaching creature, wings aloft. A painting of chrysanthemums, contained in *Hours of Gladness*, is a glorious acknowledgement of the artist's debt to William Morris and Burne-Jones. Detmold's work was not entirely confined to subjects drawn from nature, and when opportunity permitted he was eager to display his talents in other areas. He undertook to illustrate the stories of Hans Andersen, a keenly competitive field, but, alas, his completed work, of great distinction and charm, was never published. In *The Arabian Nights* (1922) Detmold was able to indulge his imaginative fancy for exotic decoration and improbable theme. Set within characteristically ornate borders, *The Rukh Which Fed Its Young on Elephants* (Plate 36) effectively demonstrates this combination, the giant bird's outstretched wings – a delight of the artist's – contributing a sense of visual exhilaration to the picture. Where effects of heat and light are called for, in those illustrations of camels in the desert, or the painting *Revealing Such Treasure*, Detmold betrays an indebtedness to J. M. W. Turner.

Mystic Resignation

'I seek unity – diversity is in the nature of things.

I seek peace – strife is in the nature of things.
I seek the unbounded – limitation is in the nature
 of things.
Strength declines, passion cools, beauty fades –
 all things perish.'

E. J. Detmold

A decade of intense activity was drawing to a close. Detmold could look back upon some fine achievements, but he was disillusioned with many of the uninspiring commissions for children's books he had undertaken. A pointless and destructive world war emphasized his worst forebodings of man's direction in the new century. The happiness of his childhood and the loss of his twin brother, now recollected in an uneasy tranquillity, combined to produce an existential crisis in the artist. In the wake of feeling that life for him had become meaningless and intolerable, he produced a literary work which testifies to his readings in Schopenhauerian pessimism and the Buddhist philosophy of the *Upanishads* and the *Bhagavad-Gita*. *Life*, his only unillustrated work, a book of aphorisms, was published by J. M. Dent in 1921. A key book to an understanding of Detmold's mind, *Life* is an inauspicious-looking small volume printed on one side of the leaf only. In his preface the author writes: 'The following words have come to the writer, over a period of many years, as the fruits of self-overcoming.' From the curious, mystical text we learn that there are two ways of attainment: 'The direct positive way – through progressive liberation – passing from the lesser realization of the body, to the greater realization of the mind, and therefrom to the realization of the infinite through the soul; and the direct negative way – through disillusionment – which comes of infatuation with things in themselves, and the inevitable passing thereof.' In the event, *Life* was Detmold's farewell to the public world of books, and his testament.

Resigned from the world, Detmold went to live in Montgomeryshire where, after a long retirement and almost totally forgotten, he died in July

1957. Strangely, there exists no official record of his death.

Detmold wrote: 'Before we can live truly, first must we seek and attain the truth of living . . . Within a man, beyond his conceiving, there am I.' In the mysterious preoccupations of insects, in the flight of birds and the ways of animals, Detmold found a meaning, an allegory of man's predicament. In man's scientific quest the noble ends of knowledge are sacrificed if his only way lies in the ruthless exploitation of his natural inheritance to the point of exhaustion. Detmold's art preserves only the image of those quiet, fragile creatures which also occupy this planet. We must decide whether natural survival, not only of the fittest, is preferable to the blind extinction man will reach on his present course.

KEITH NICHOLSON
August 1975

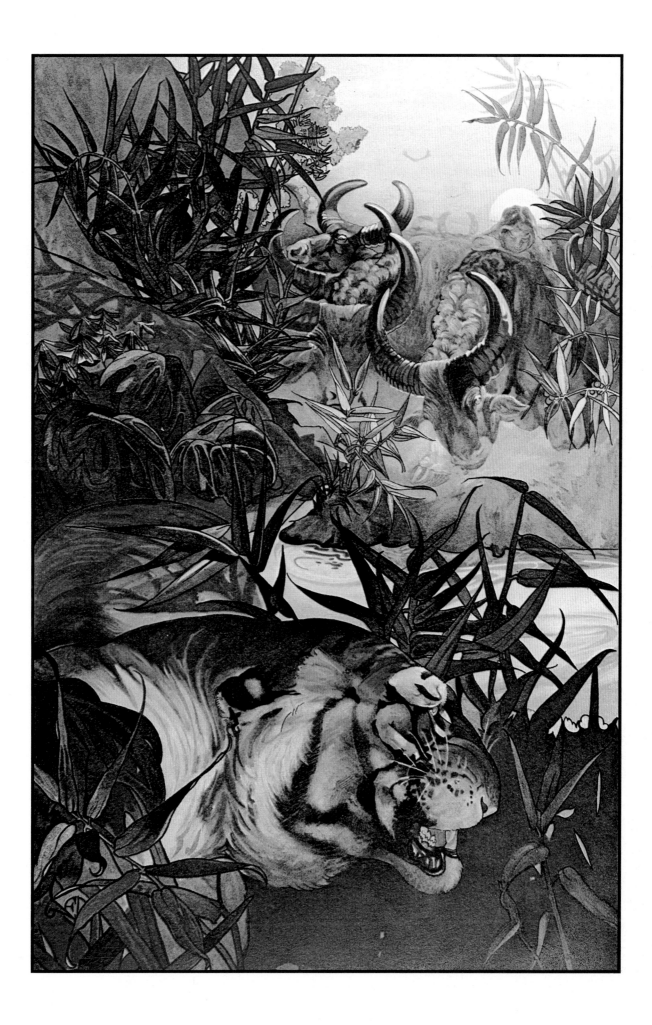

1) Shere Khan in the Jungle
" 'Fla! Fla!' said Mowgli, on his back. 'Now thou
knowest!' and the torrent of black horns, foaming
muzzles and staring eyes whirled down the ravine
like boulders in flood-time; the weaker buffaloes
being shouldered out to the sides of the ravine,
where they tore through the creepers."

The Jungle Book

MACMILLAN & CO.

1903

Victoria & Albert Museum
Photo—M. Slingsby

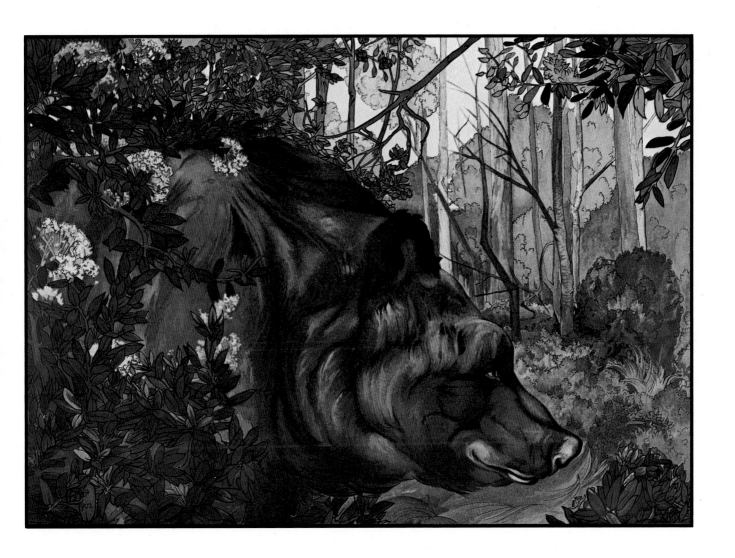

2) Baloo in the Forest
" 'Haste! O haste! We - we may catch them yet!'
Baloo panted."

The Jungle Book

MACMILLAN & CO.

1903

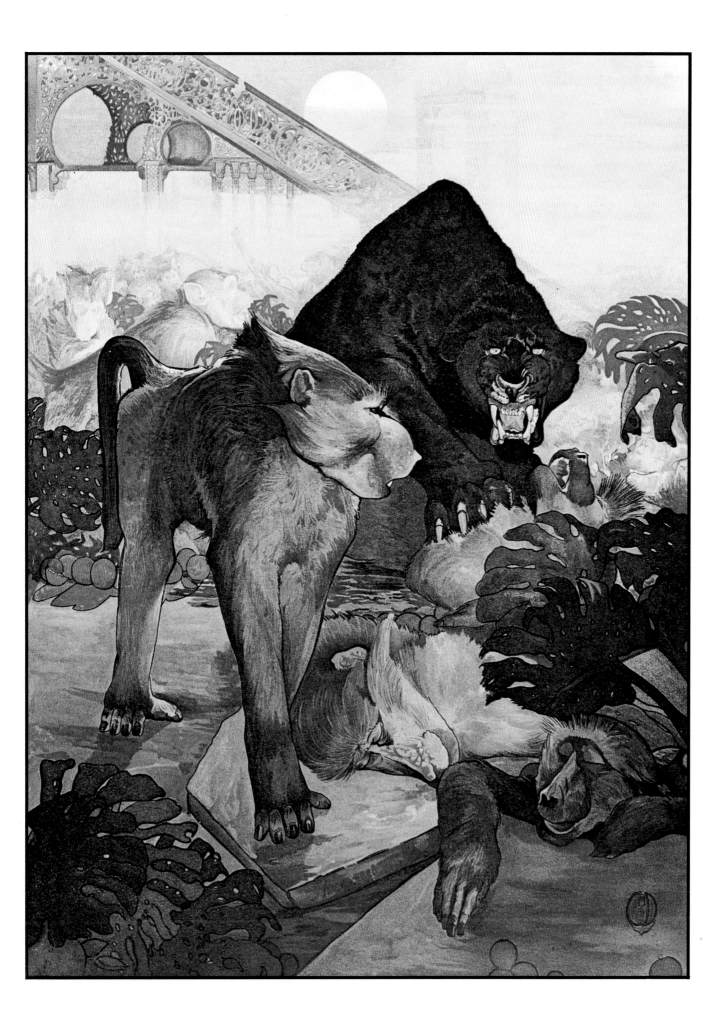

3) Monkey Fight

"There was a howl of fright and rage, then as
Bagheeva tripped on the rolling, kicking bodies
beneath him, a monkey shouted 'There is only one
here! Kill him! Kill.' "

The Jungle Book

MACMILLAN & CO.

1903

Victoria & Albert Museum
Photo—M. Slingsby

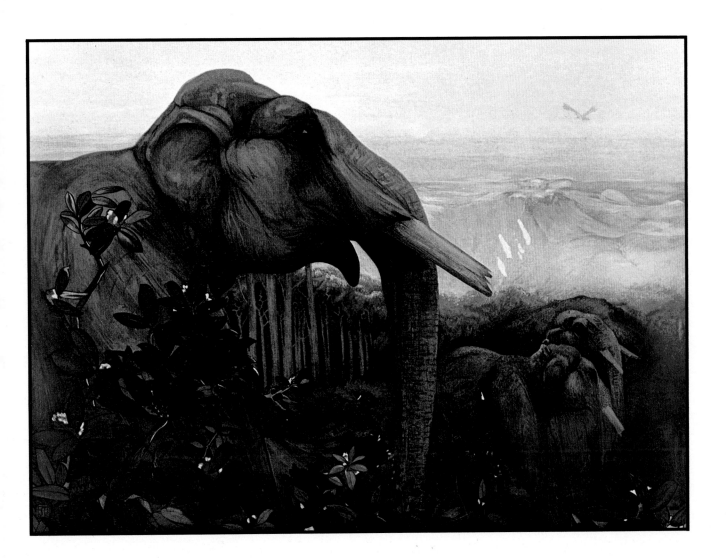

4) Toomai of the Elephants

"The morning broke in one sheet of pale yellow
behind the green hills, and the booming stopped
with the first ray, as though the light had been an
order. Before Little Toomai had got the ringing out
of his head, before even he had shifted his position,
there was not an elephant in sight except Kala,
Nag Pudmini, and the elephant with the rope-galls,
and there was neither sign nor rustle nor whisper
down the hillsides to show where the others
had gone."

The Jungle Book

MACMILLAN & CO.

1903

Victoria & Albert Museum
Photo—M. Slingsby

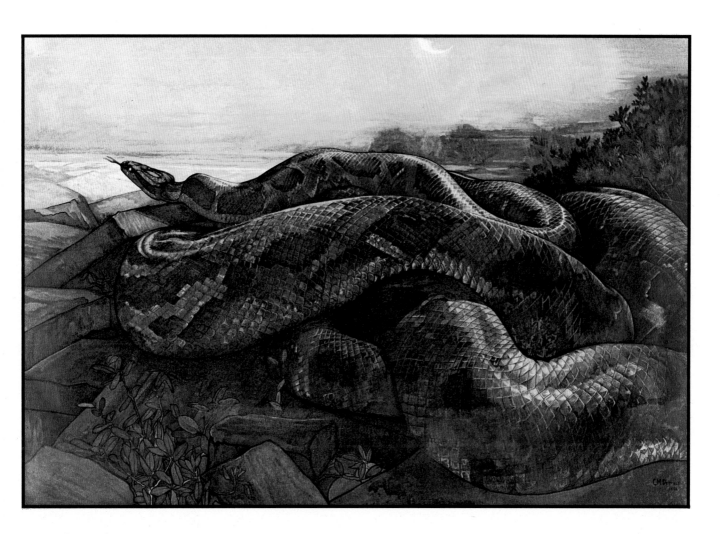

5) Charles Maurice Detmold

Kaa the Python
"Kaa had only just worked his way over the west
wall, ending with a wrench that dislodged a
coping-stone into the ditch."

The Jungle Book

MACMILLAN & CO.

1903

Victoria & Albert Museum
Photo—M. Slingsby

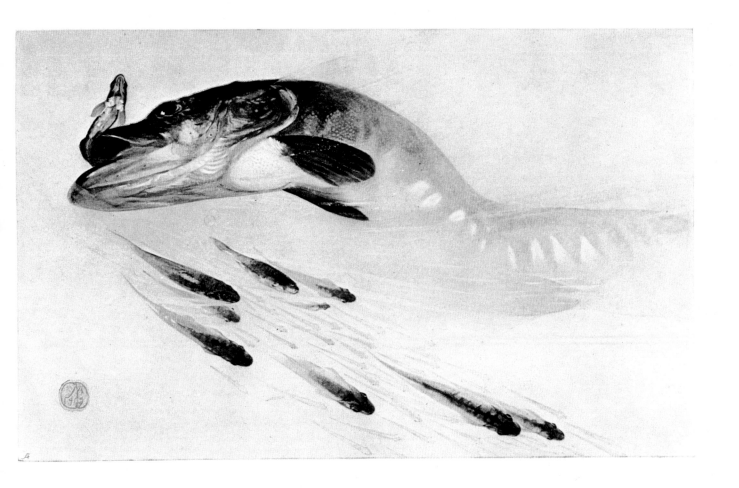

6) Charles Maurice Detmold

Fish and Small Fry

THE STUDIO, AN ILLUSTRATED MAGAZINE OF FINE AND
APPLIED ART
Volume 38

1906

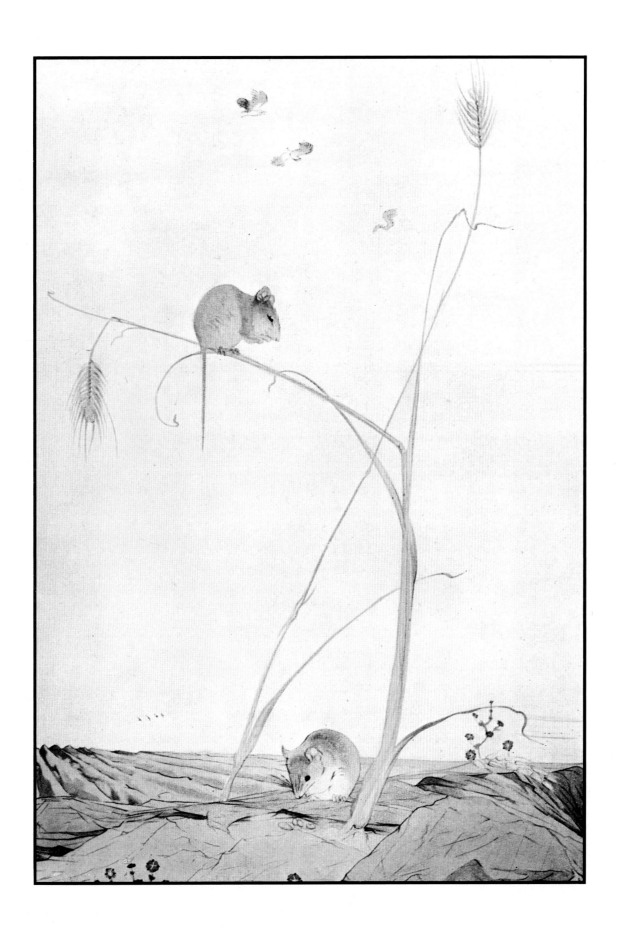

7) The Town Mouse and the Country Mouse

The Fables of Aesop

HODDER & STOUGHTON

1909

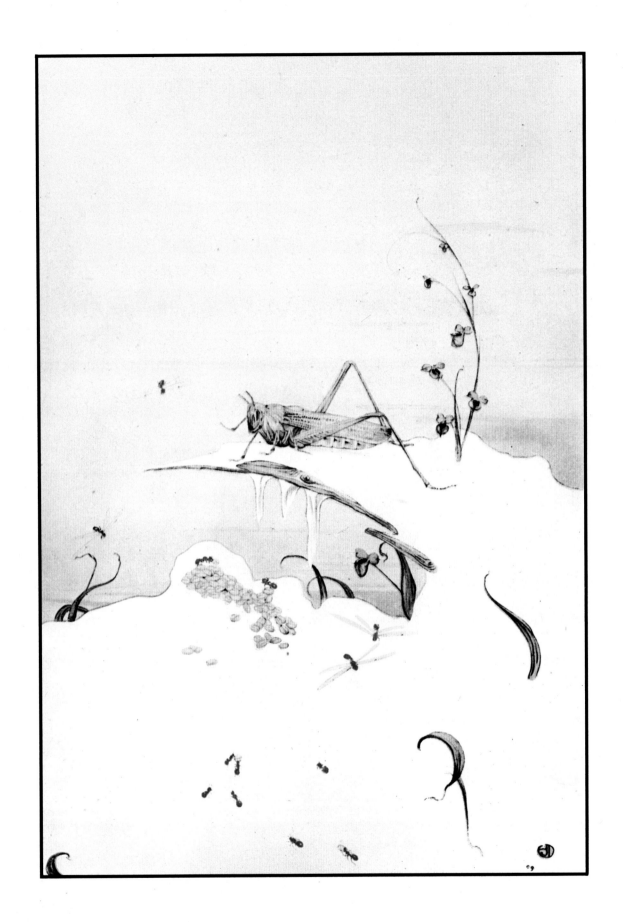

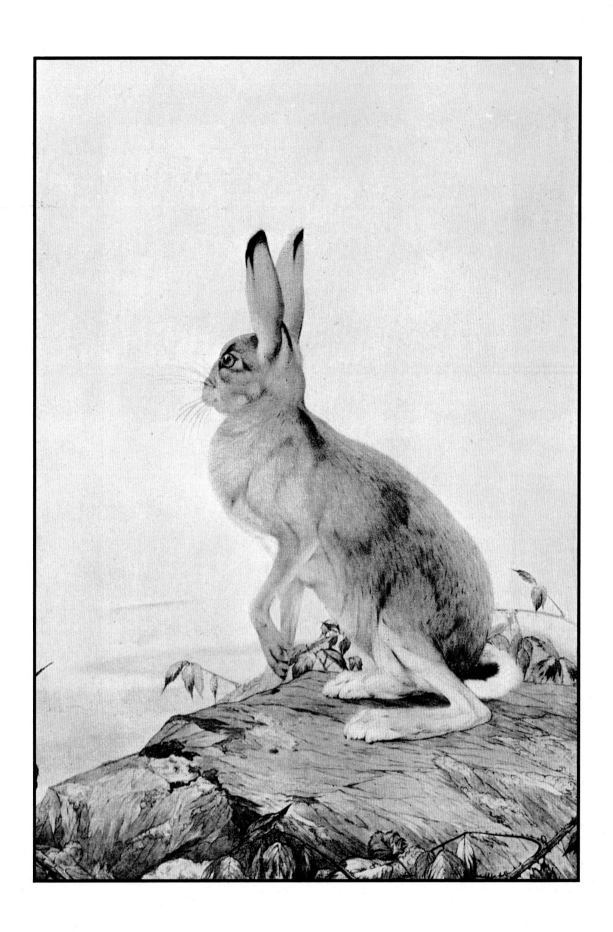

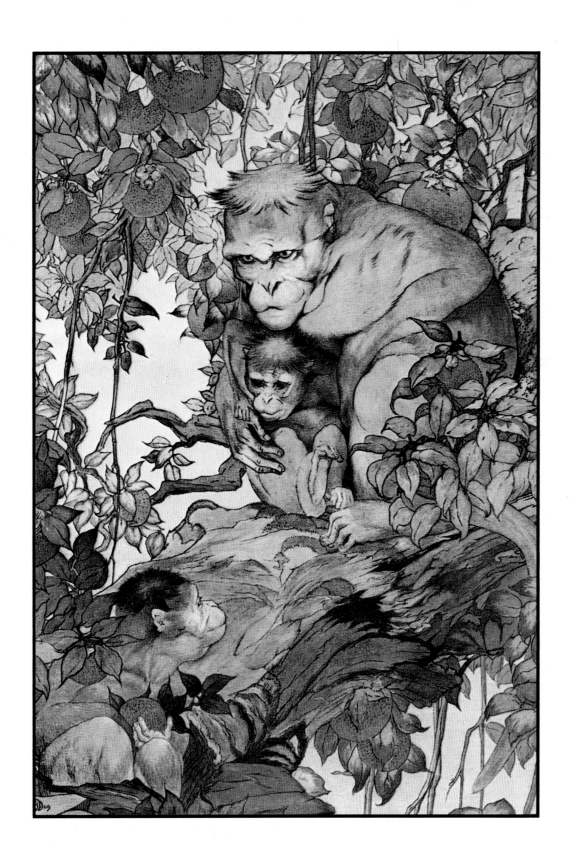

10) The Monkeys and their Mother

The Fables of Aesop

HODDER & STOUGHTON

1909

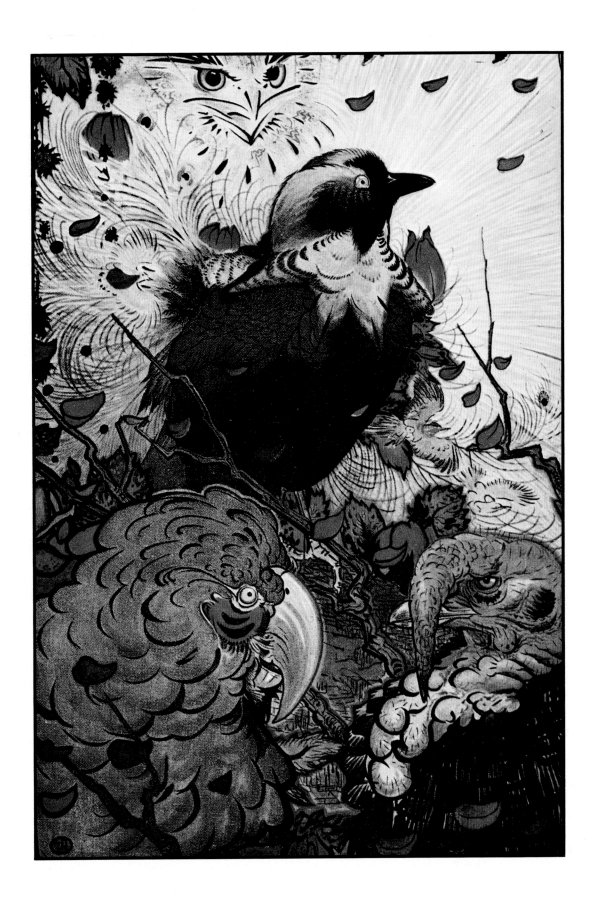

11) The Vain Jackdaw

The Fables of Aesop

HODDER & STOUGHTON

1909

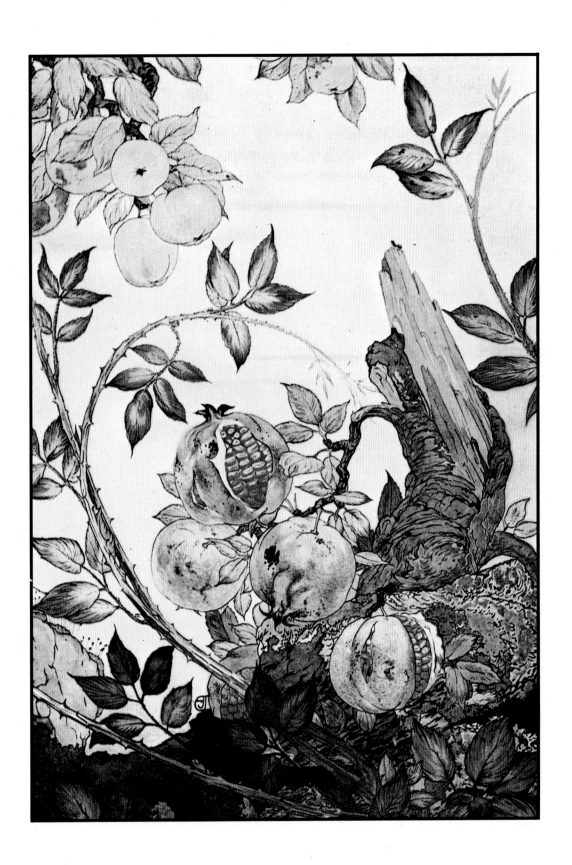

12) Pomegranate, Apple-tree and Bramble

The Fables of Aesop

HODDER & STOUGHTON

1909

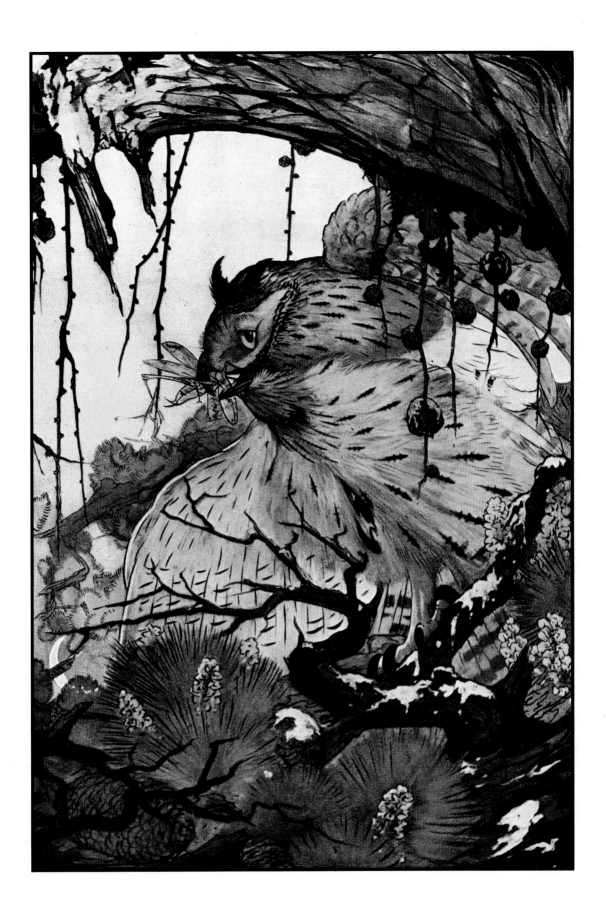

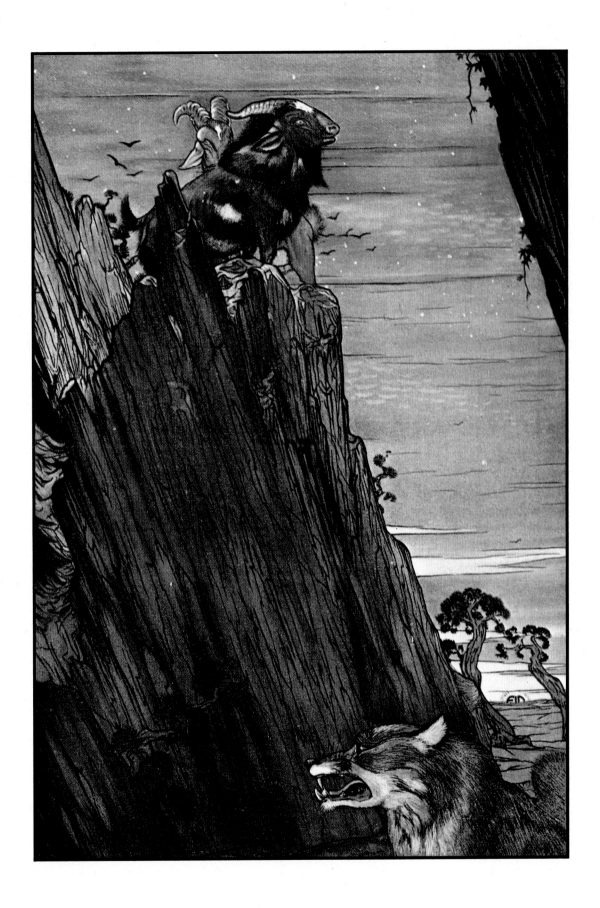

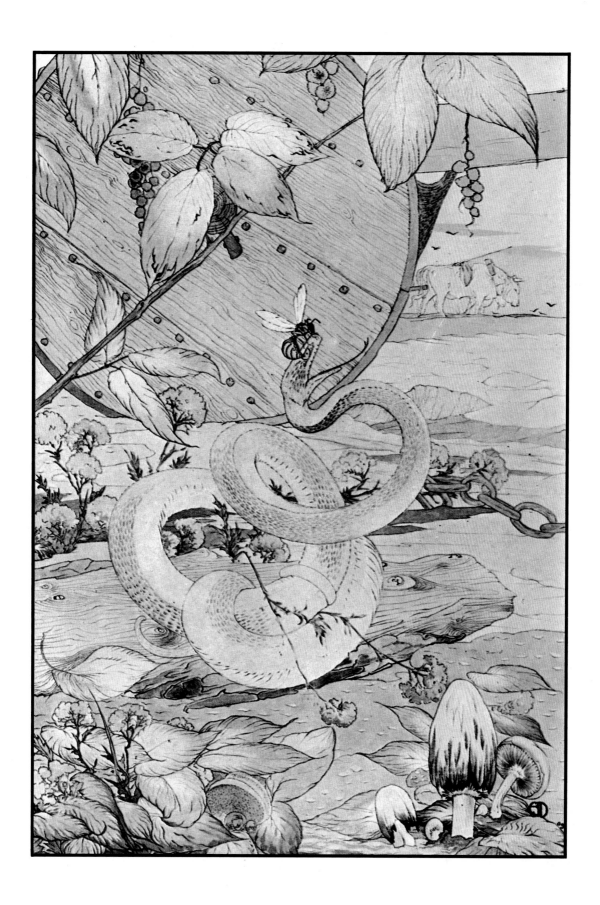

15) The Wasp and the Snake

The Fables of Aesop

HODDER & STOUGHTON

1909

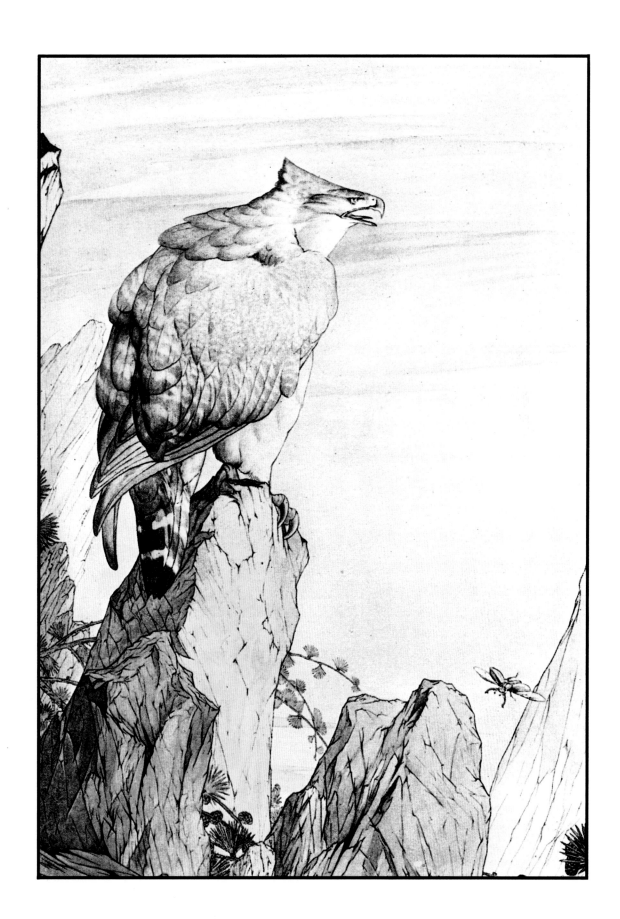

16) The Eagle and the Beetle

The Fables of Aesop

HODDER & STOUGHTON

1909

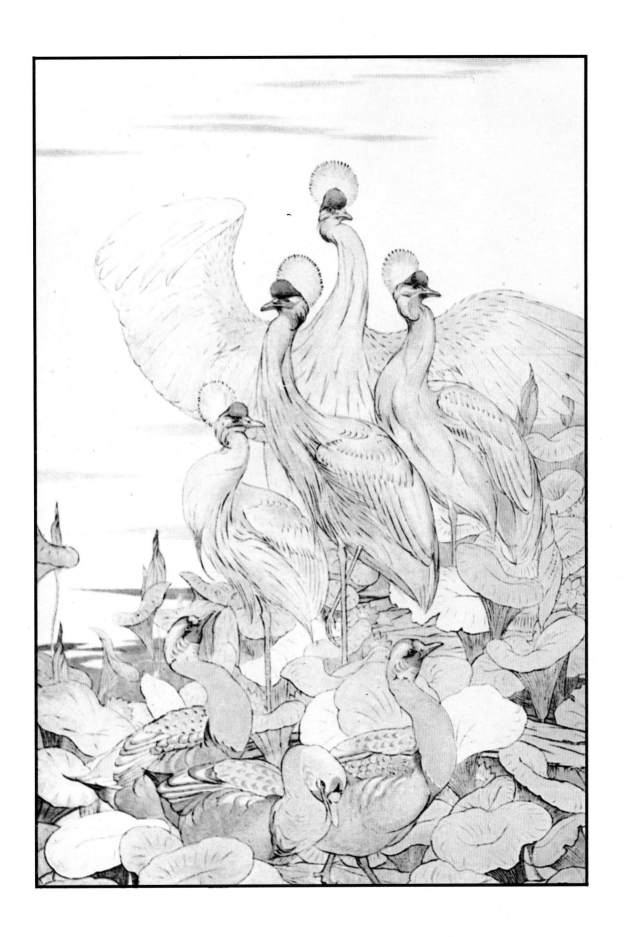

17) The Geese and the Cranes

The Fables of Aesop

HODDER & STOUGHTON

1909

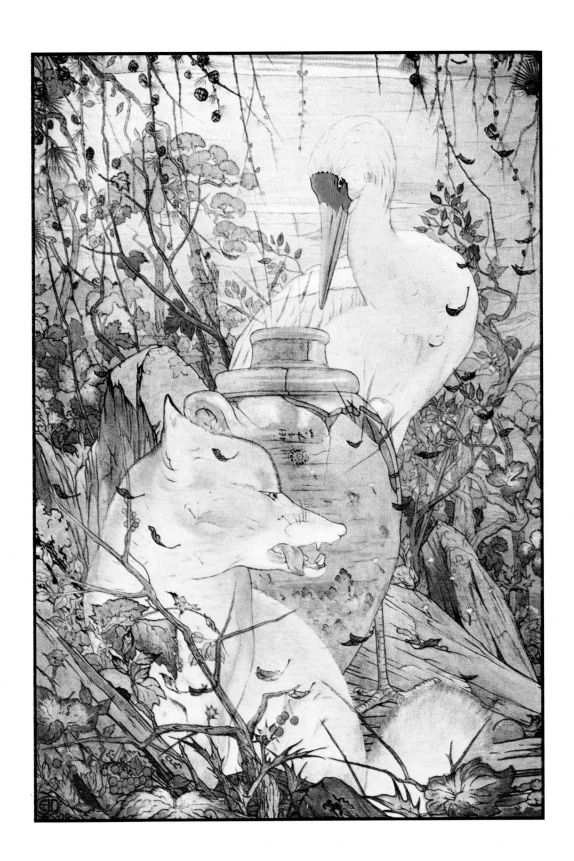

18) The Fox and the Crane

The Fables of Aesop

HODDER & STOUGHTON

1909

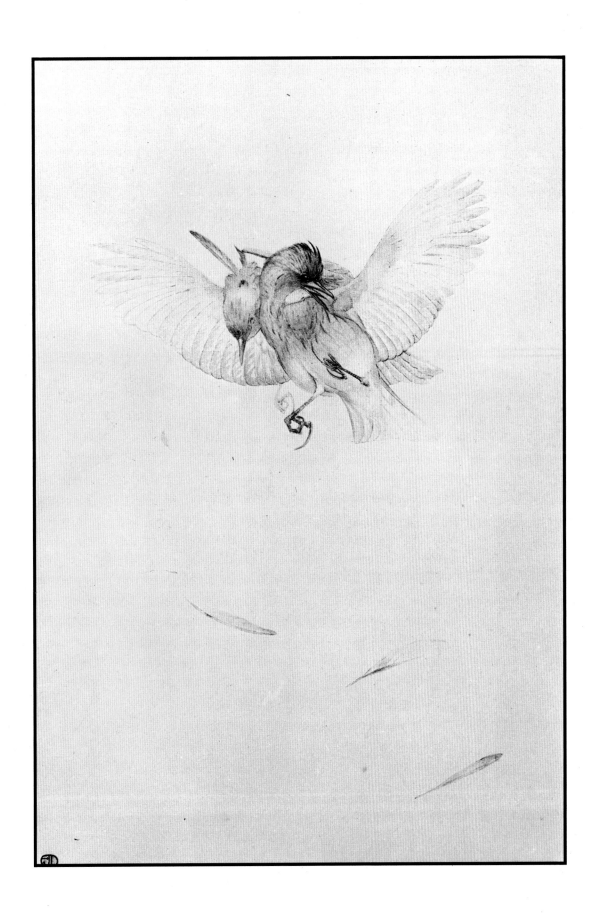

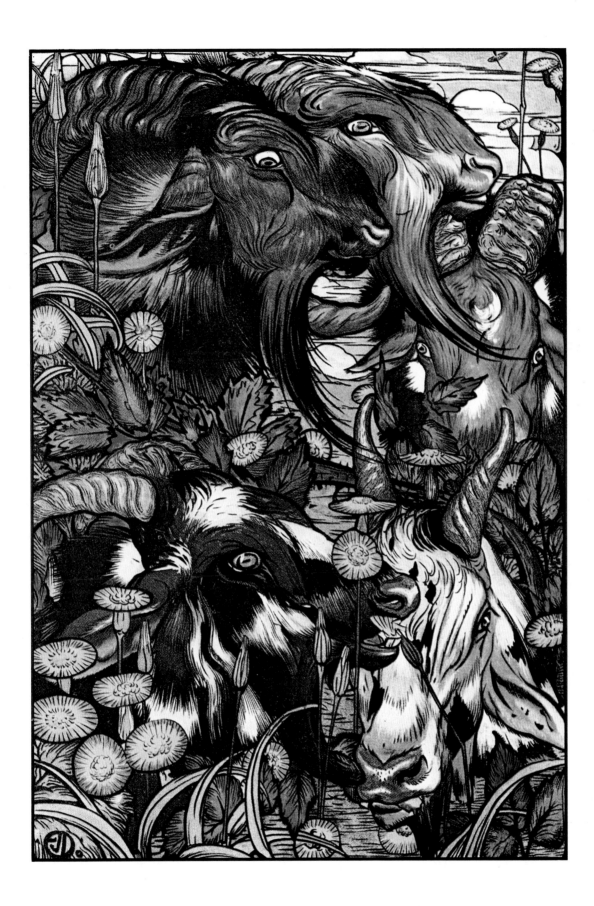

The Fables of Aesop

HODDER & STOUGHTON

1909

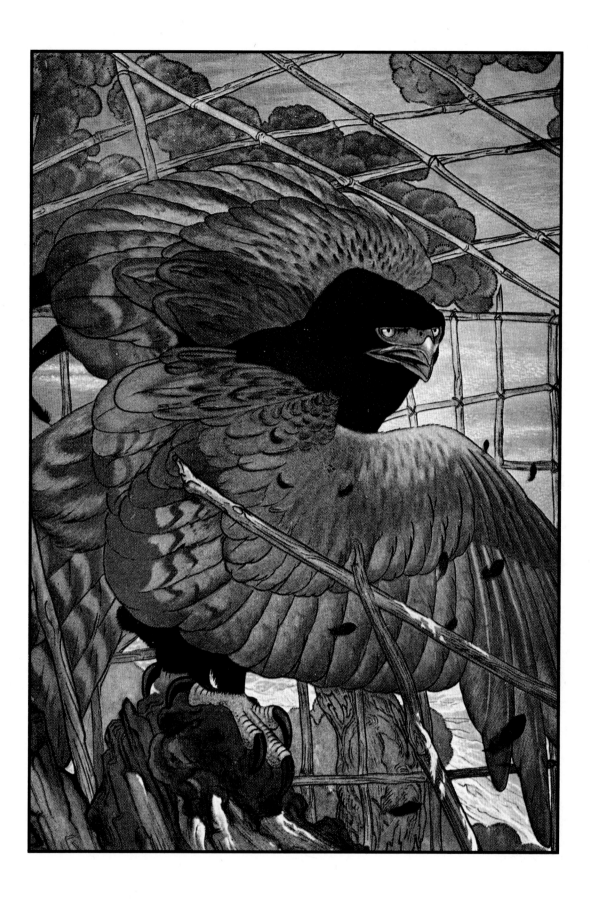

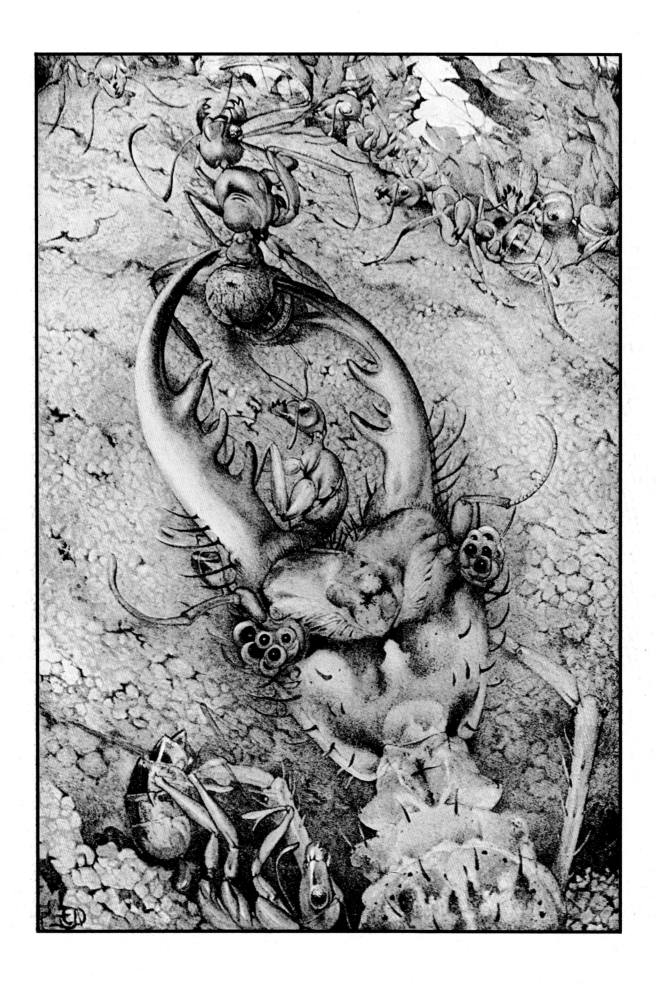

22) The Ant Lion

Princess Mary's Gift Book

HODDER & STOUGHTON

1914

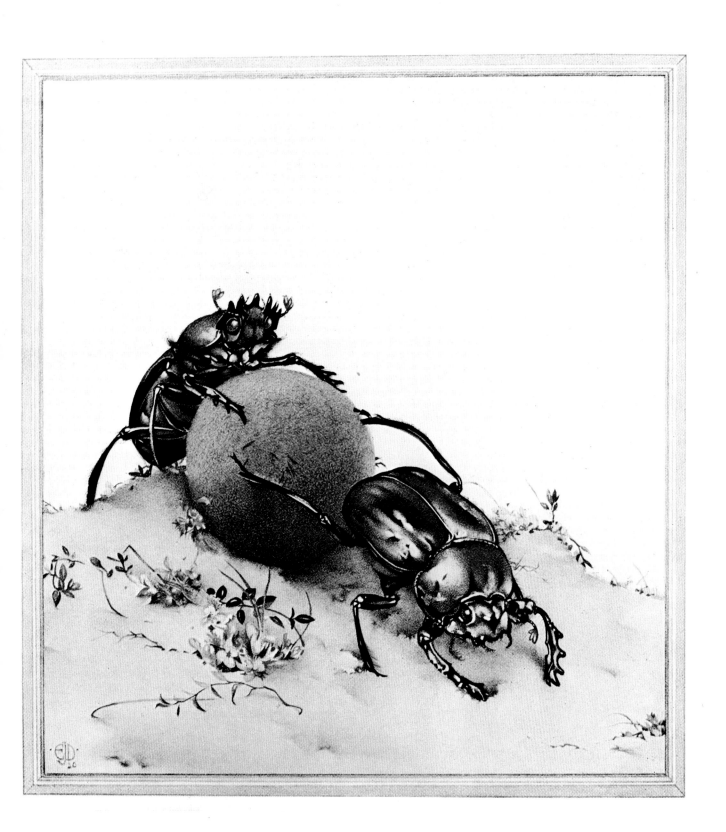

23) The Sacred Beetle

Fabre's Book of Insects

HODDER & STOUGHTON

1921

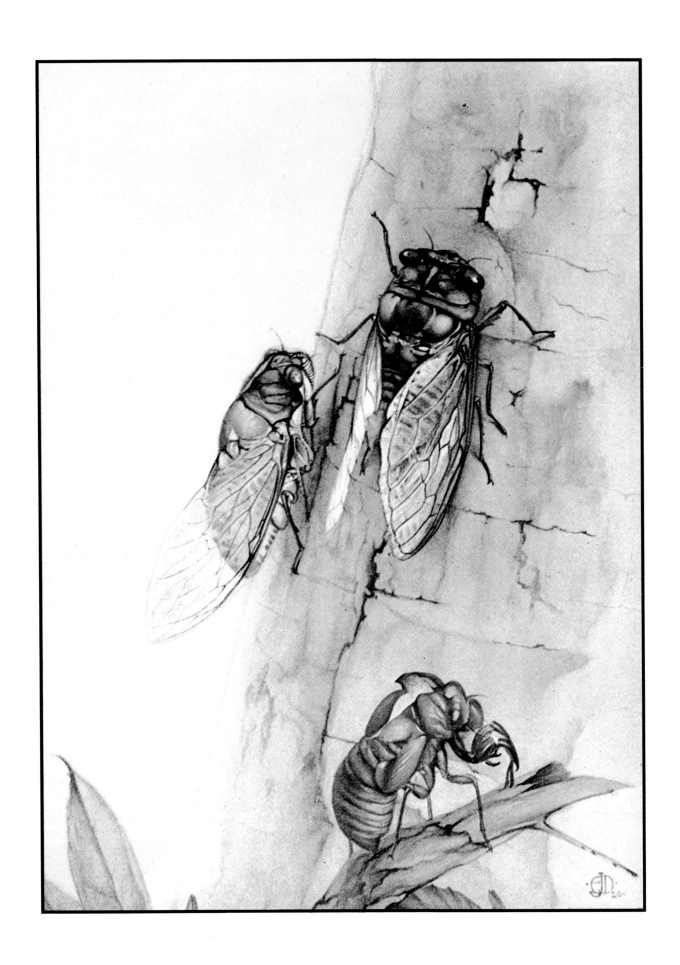

24) The Cicada

Fabre's Book of Insects

HODDER & STOUGHTON

1921

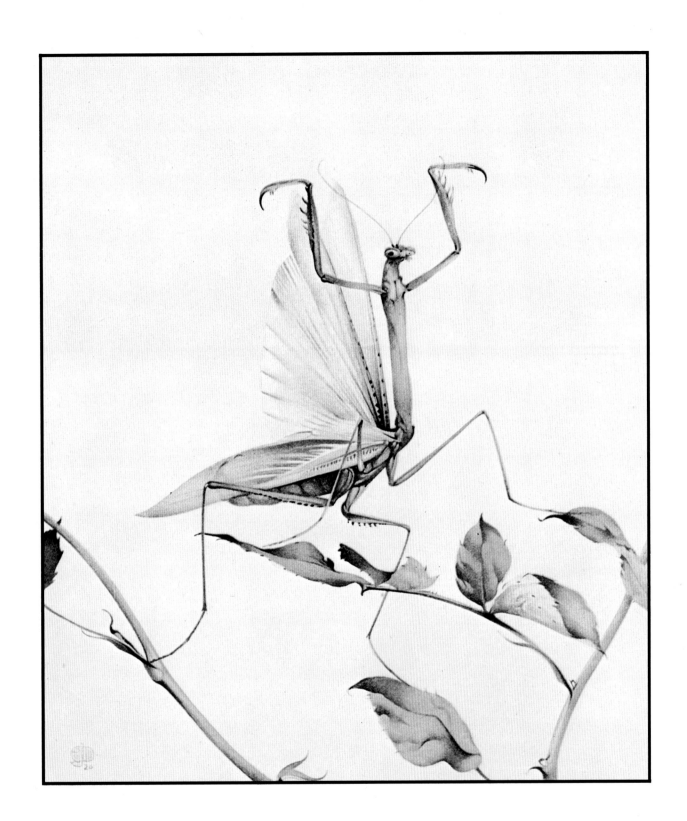

25) The Praying Mantis

Fabre's Book of Insects

HODDER & STOUGHTON

1921

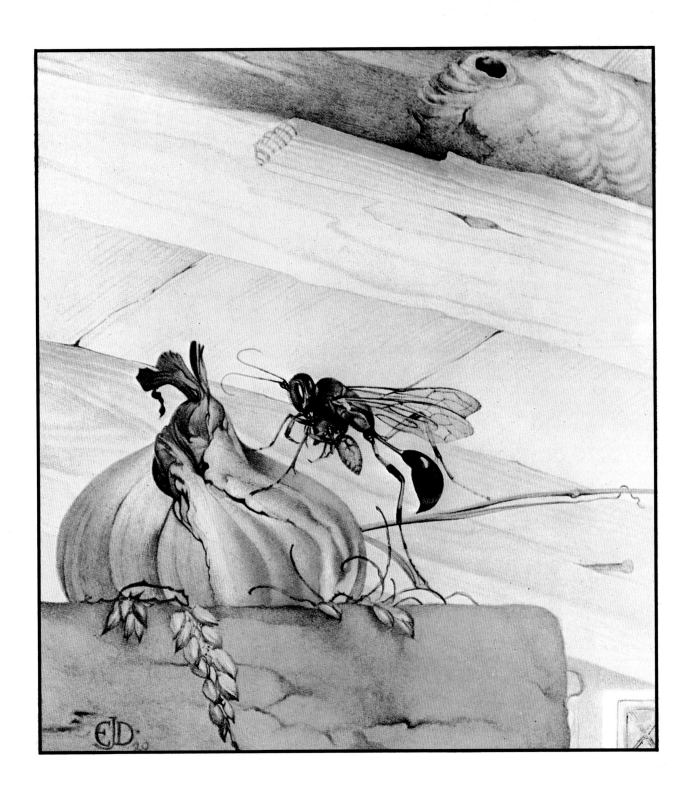

26) Pelopaeus Spirifex

Fabre's Book of Insects

HODDER & STOUGHTON

1921

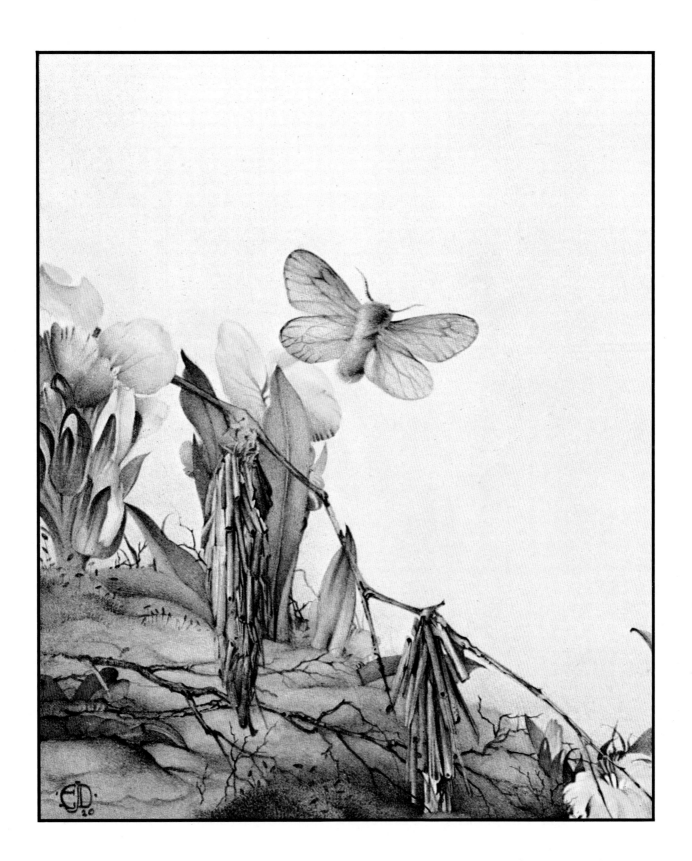

27) Psyche

Fabre's Book of Insects

HODDER & STOUGHTON

1921

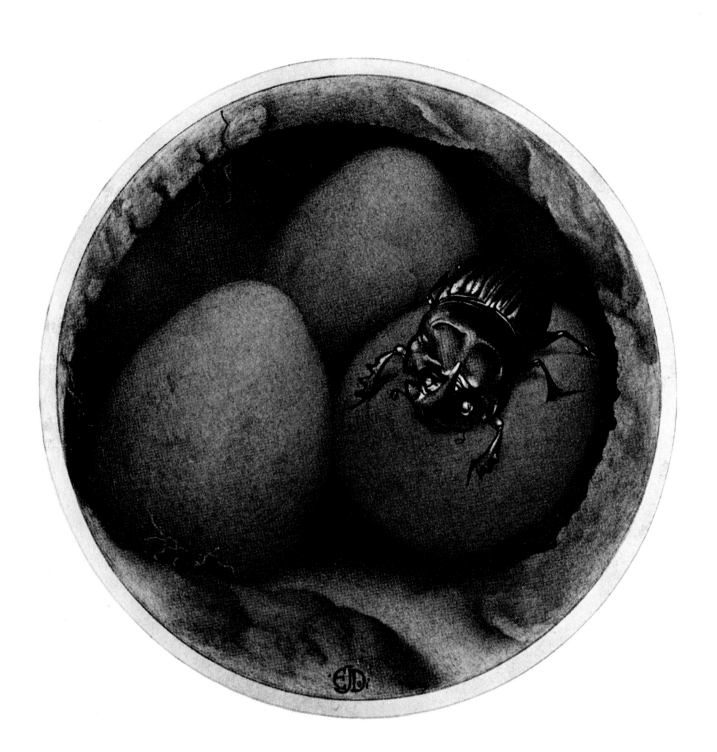

28) The Spanish Copris and Ovoids

Fabre's Book of Insects

HODDER & STOUGHTON

1921

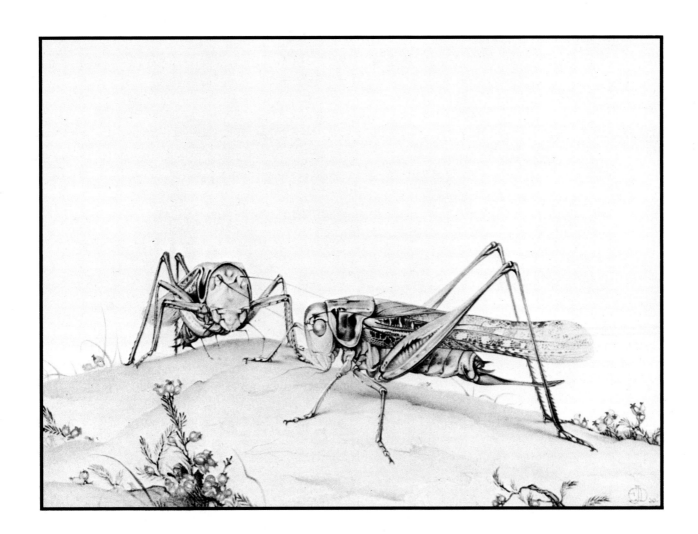

29) The White-faced Decticus

Fabre's Book of Insects

HODDER & STOUGHTON

1921

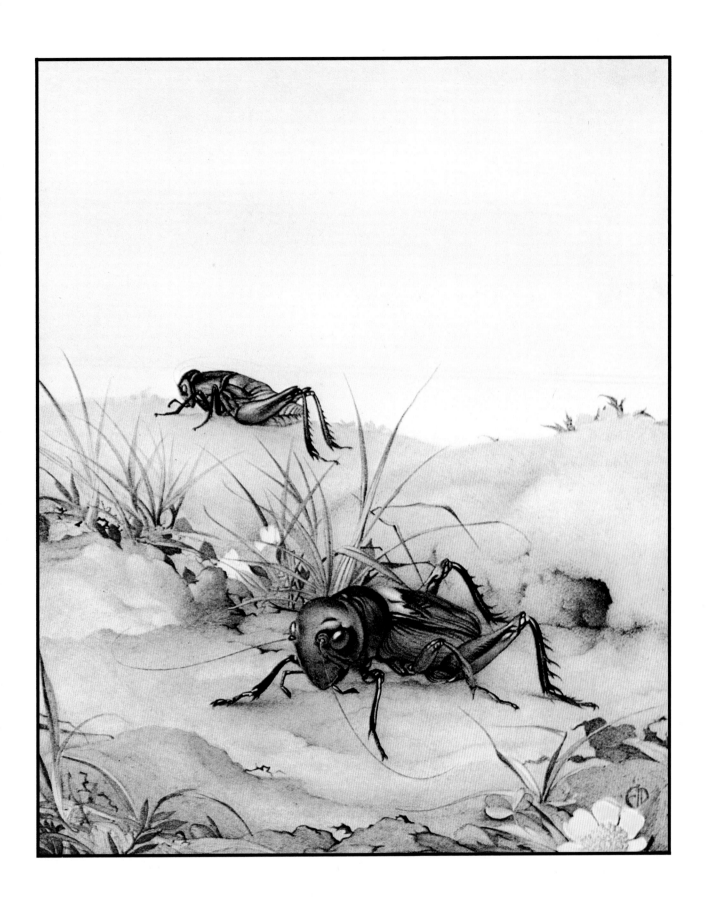

31) The Field Cricket

Fabre's Book of Insects

HODDER & STOUGHTON

1921

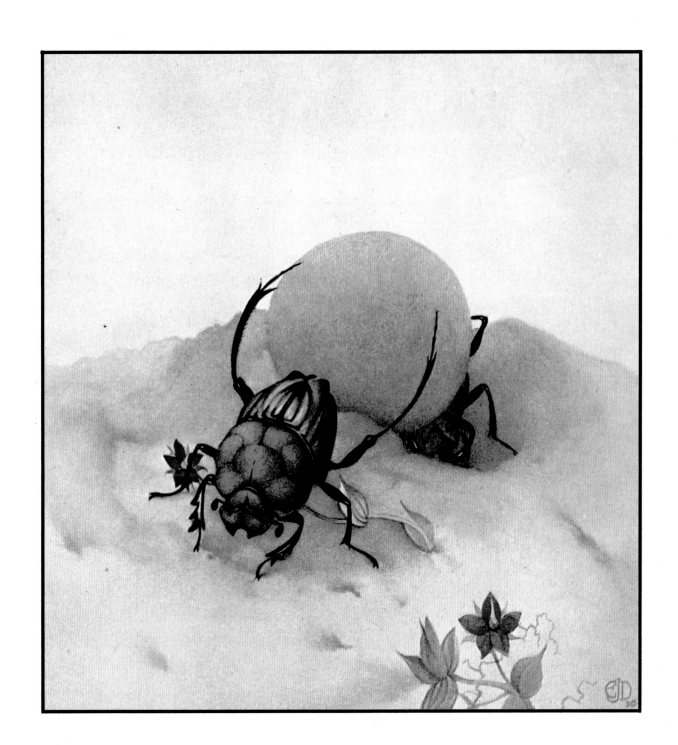

32) Sisyphus

Fabre's Book of Insects

HODDER & STOUGHTON

1921

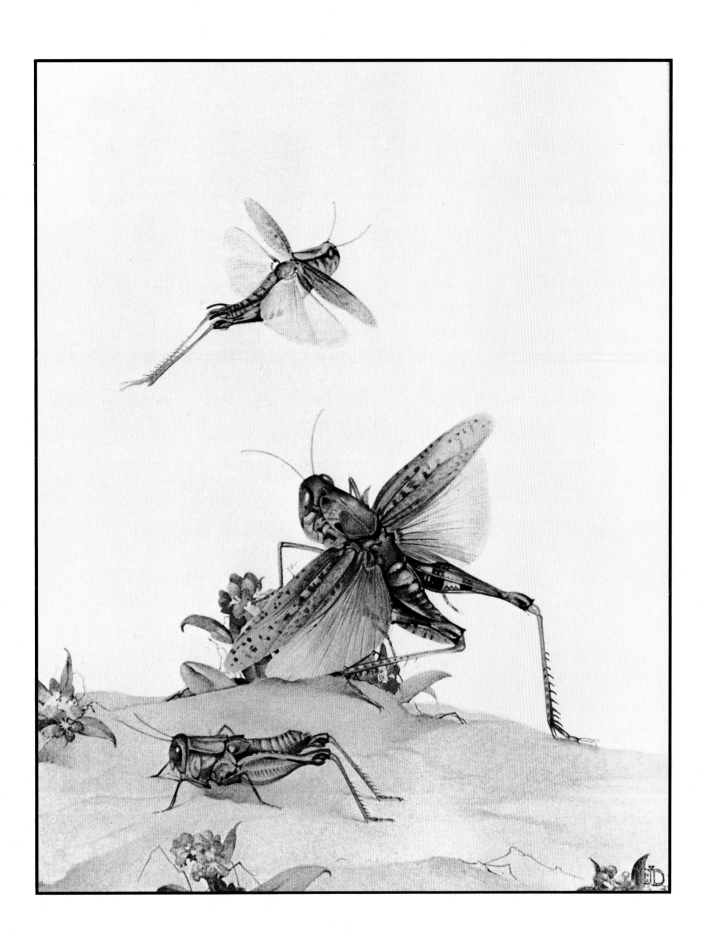

33) Italian Locusts

Fabre's Book of Insects

HODDER & STOUGHTON

1921

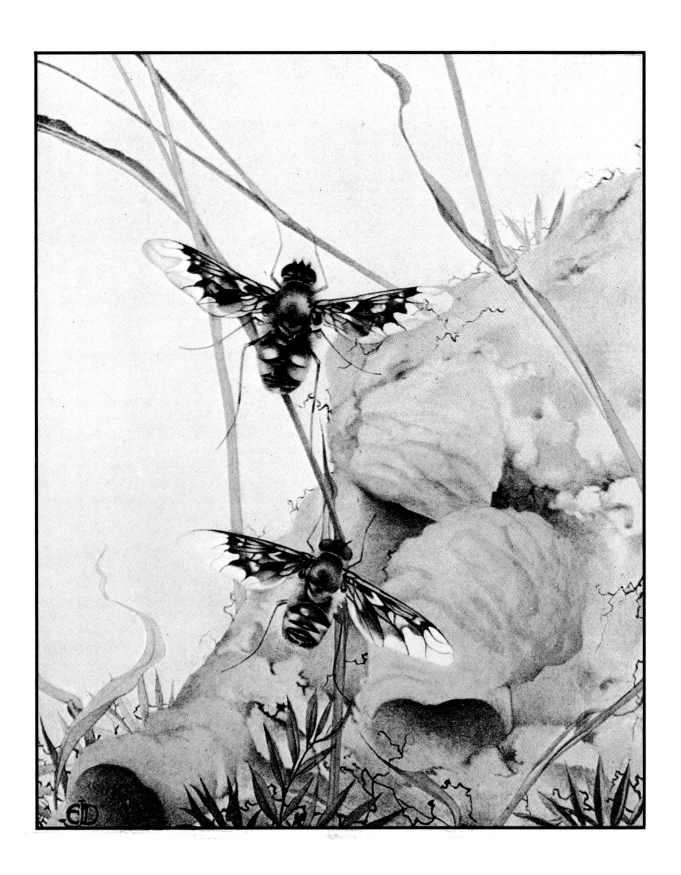

34) Anthrax Fevestrata

Fabre's Book of Insects

HODDER & STOUGHTON

1921

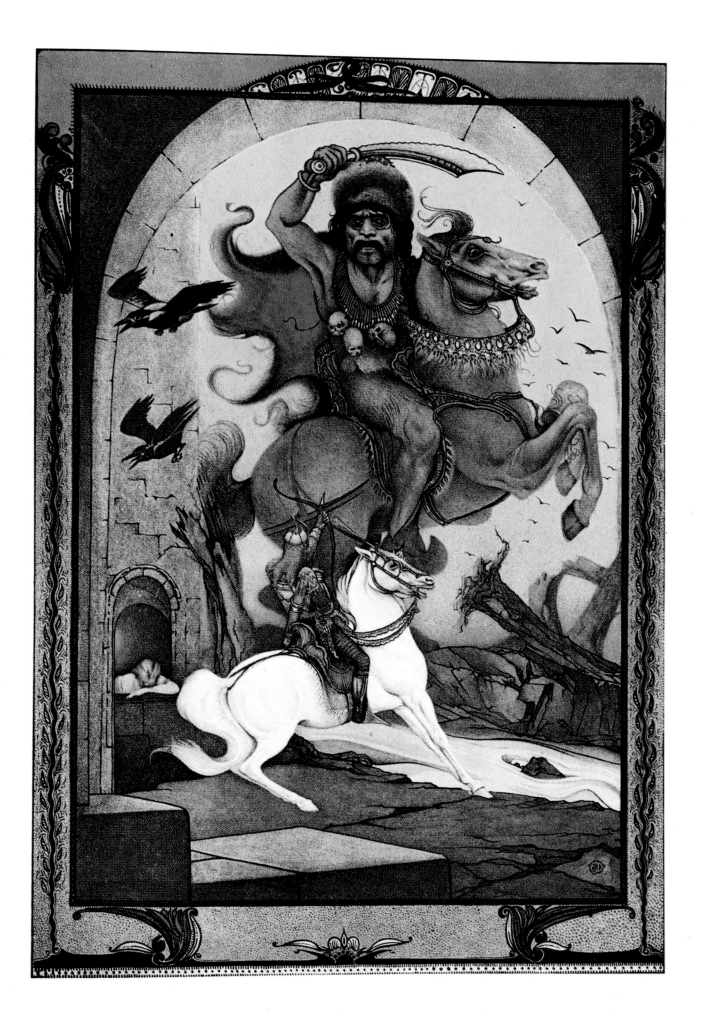

35) Drawing his scimitar aimed at him a blow
which, had it found him, must there and then
have ended the fight.

The History of Codadad and his Brothers and of the
Princess Deryabar

Arabian Nights

HODDER & STOUGHTON

1922

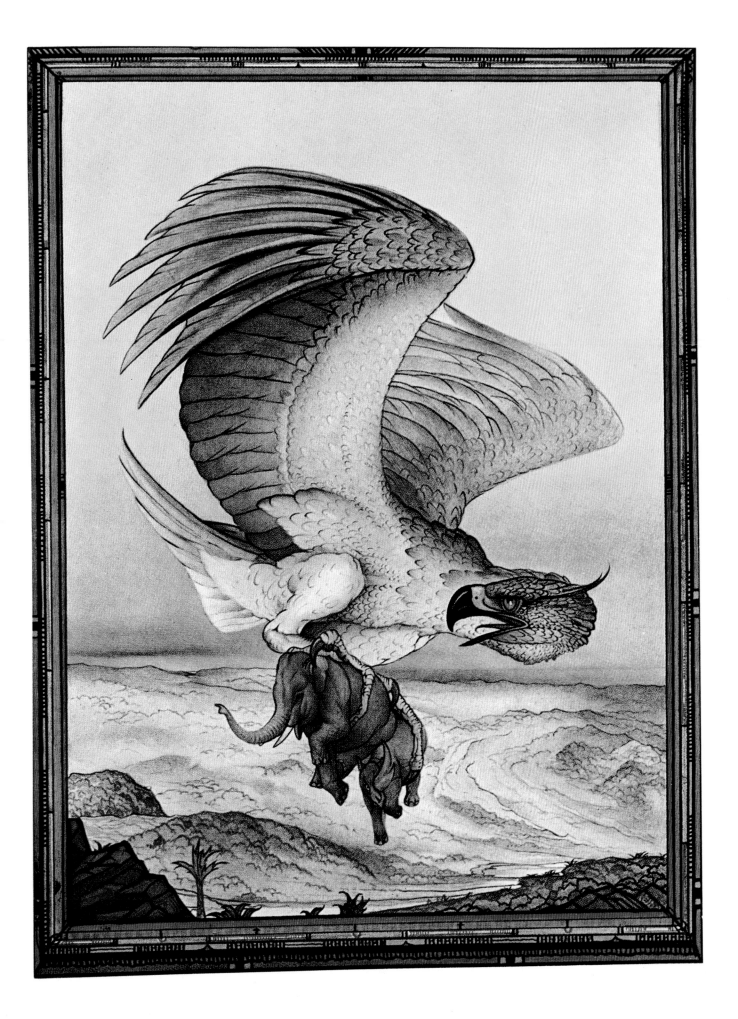

36) The Rukh which fed its young on elephants.

Sinbad the Sailor

Arabian Nights

HODDER & STOUGHTON

1922

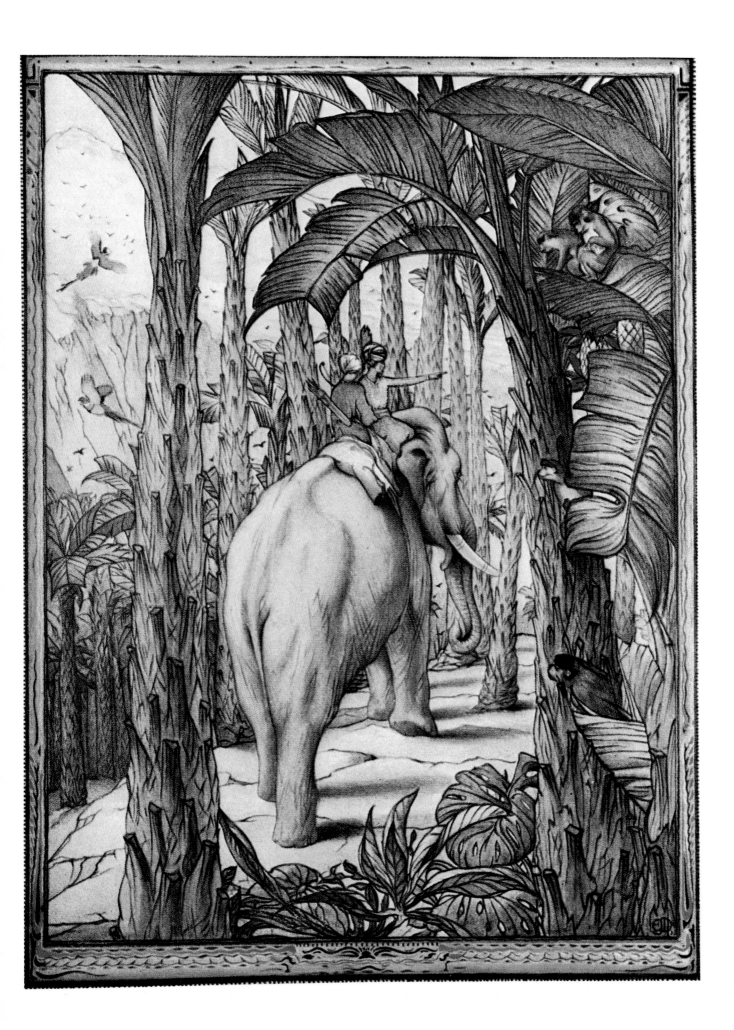

37) The next day he sat me behind him on an elephant.

Sinbad the Sailor

Arabian Nights

HODDER & STOUGHTON

1922

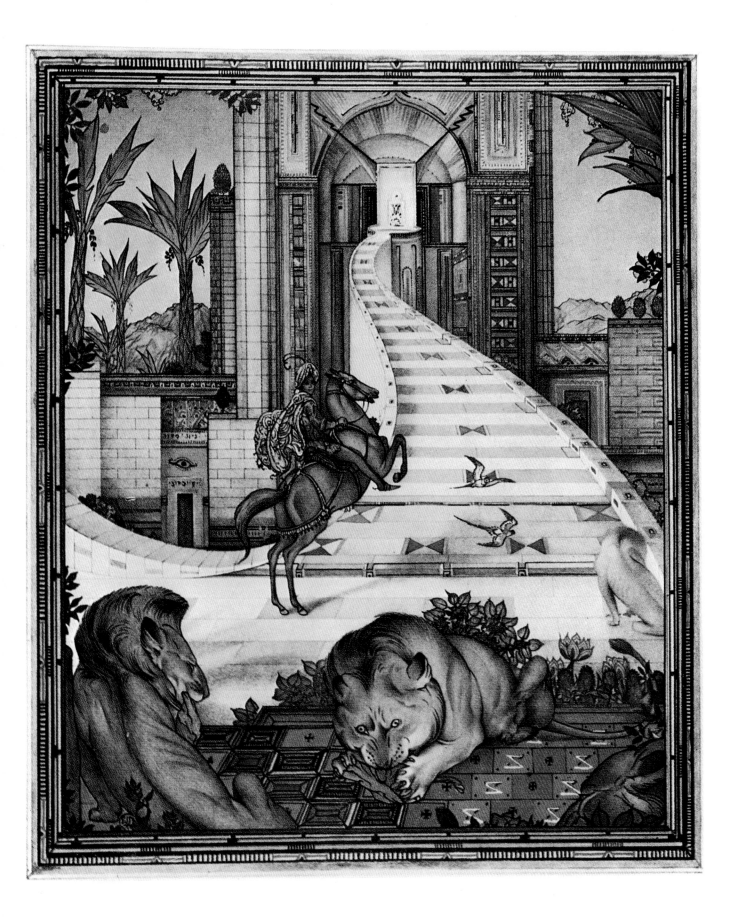

38) Whilst they were yet devouring the meat, he
hastily filled his flagon.

The Story of Prince Assad and the Fairy Pirie Nashara

Arabian Nights

HODDER & STOUGHTON

1922

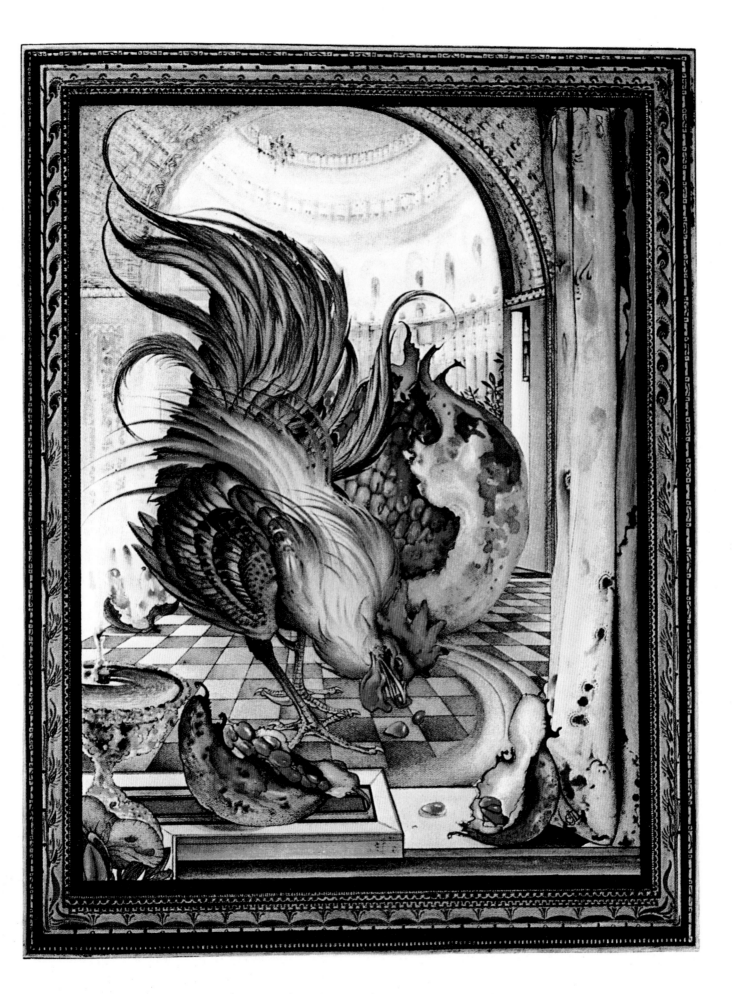

39) The wolf changed into a cock which began
picking up the grains.

The Three Calenders

Arabian Nights

HODDER & STOUGHTON

1922

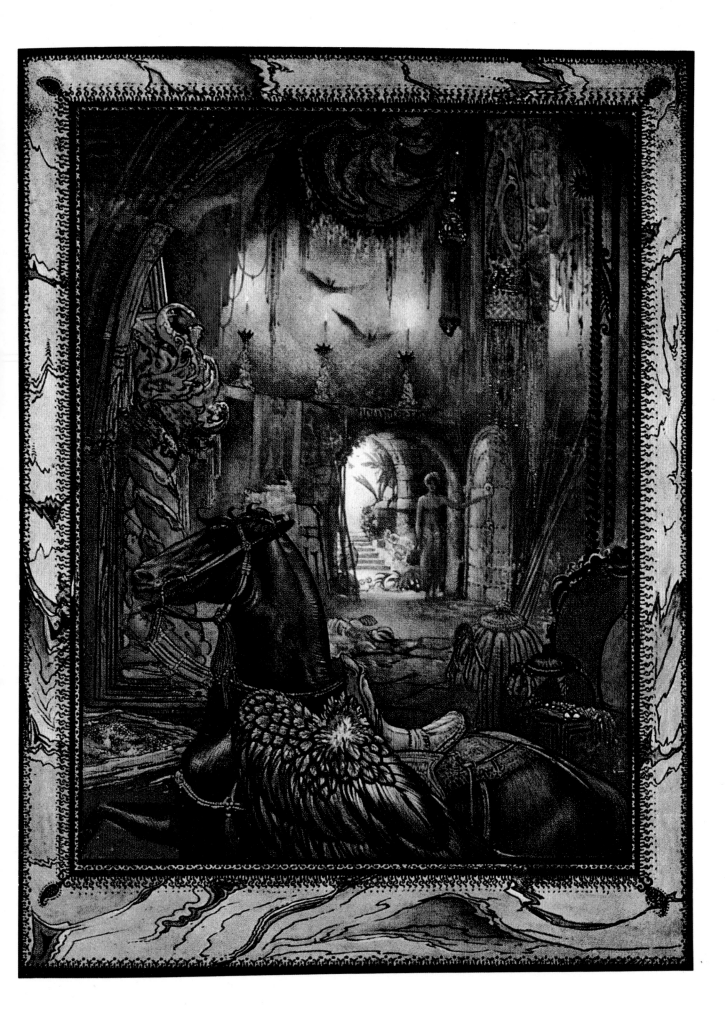

40) A magnificent steed as black as night.

The Three Calenders

Arabian Nights

HODDER & STOUGHTON

1922